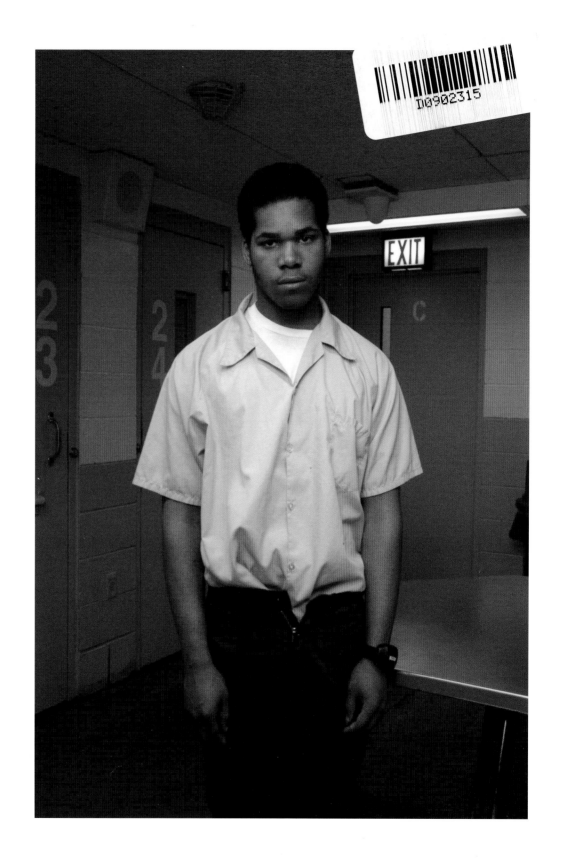

Fiona Tan *Correction*

Exhibition Curators
Francesco Bonami
Julie Rodrigues Widholm

Museum of
Contemporary Art,
Chicago

New Museum of
Contemporary Art,
New York

Hammer Museum,
Los Angeles

This catalogue is published in conjunction with the exhibition *Fiona Tan: Correction*, part of a series of commissioned works organized and presented by the Museum of Contemporary Art, Chicago; Hammer Museum, Los Angeles; and New Museum of Contemporary Art, New York.

Museum of Contemporary Art, Chicago
October 2, 2004 – January 23, 2005

New Museum of Contemporary Art, New York
April 8 – June 4, 2005

Hammer Museum, Los Angeles
June 26 – October 16, 2005

Generous support for this series has been provided by the Peter Norton Family Foundation and the American Center Foundation.

Fiona Tan: Correction also received support from the Mondriaan Foundation, Amsterdam, and The Consulate General of The Netherlands in New York. This exhibition catalogue is supported in part by the Elizabeth Firestone Graham Foundation.

Mondriaan Stichting
(Mondriaan Foundation)

The Museum of Contemporary Art, Chicago (MCA), is a nonprofit, tax-exempt organization. The MCA's exhibitions, programming, and operations are member supported and privately funded through contributions from individuals, corporations, and foundations. Additional support is provided through the Illinois Arts Council, a state agency. Air transportation services are provided by American Airlines, the official airline of the Museum of Contemporary Art.

Published by the Museum of Contemporary Art, Chicago, 220 East Chicago Avenue, Chicago, Illinois 60611-2643.

Produced by the Publications Department of the Museum of Contemporary Art, Chicago, Hal Kugeler, Director. Edited by Kari Dahlgren, Associate Director; designed by Kythzia Jurado de Campa, Senior Designer.

Distributed by D.A.P./Distributed Art Publishers, 155 Sixth Ave., New York, New York 10013-1507. Phone: 212.627.1999. Fax: 212.627.9484.

ISBN 0-933856-84-9
Library of Congress Catalog Number: 2004114731

Correction
2004
Color video installation

INSTALLATION VIEWS
Cover and pages 24, 27, 38 – 39, 48, 49, and 58 – 59

STILLS
Pages 1, 40 – 47, and 50 – 57

Contents

Correction, Dutch-Australian artist Fiona Tan's first video project undertaken in the United States, encompasses several hundred filmed portraits of prisoners and prison guards taken at prisons in Illinois and California. While examining the politics of representation and the power of photographic media, Tan was most interested in portraying the multitude of citizens who are hidden from the public eye. As she explores new ways of looking, we explore new ways of producing and exhibiting works through a collaboration we hope endures well into the future.

This project is the first of what our institutions — the Museum of Contemporary Art, Chicago; Hammer Museum, Los Angeles; and New Museum of Contemporary Art, New York — propose as a new model among arts organizations to commission and exhibit the work of emerging artists. Expanding on our museums' previous collaborative efforts, we share great excitement in formalizing our partnership — which we've come to refer to as the "Three M Project" — as an opportunity to work together to present new work by artists unfamiliar to many of our visitors: Patty Chang, Aernout Mik, and Fiona Tan. While our undertaking is collaborative in many ways, each project is directed by an individual museum: Chang's by the Hammer Museum, Mik's by the New Museum, and Tan's by the MCA. We hope the artists will benefit from a broader audience and increased visibility that our consortium provides. It has been our distinct honor and pleasure to work with them.

We are profoundly grateful to the Peter Norton Family Foundation and the American Center Foundation for supporting our institutions' collaboration. The Mondriaan Foundation, Amsterdam, and The Consulate General of The Netherlands, New York, provided additional support for our presentations of Fiona Tan and Aernout Mik, and the Elizabeth Firestone Graham Foundation provided funding for this catalogue. To all of these organizations, we extend our sincere thanks.

Kingdom of Shadows
2000
Black-and-white and color documentary film
Digital betacam, stereo, with versions in English, French, and Dutch
50 minutes

Robert Fitzpatrick
Pritzker Director,
Museum of Contemporary Art,
Chicago

Ann Philbin
Director, Hammer Museum,
Los Angeles

Lisa Phillips
Henry Luce III Director,
New Museum of Contemporary Art,
New York

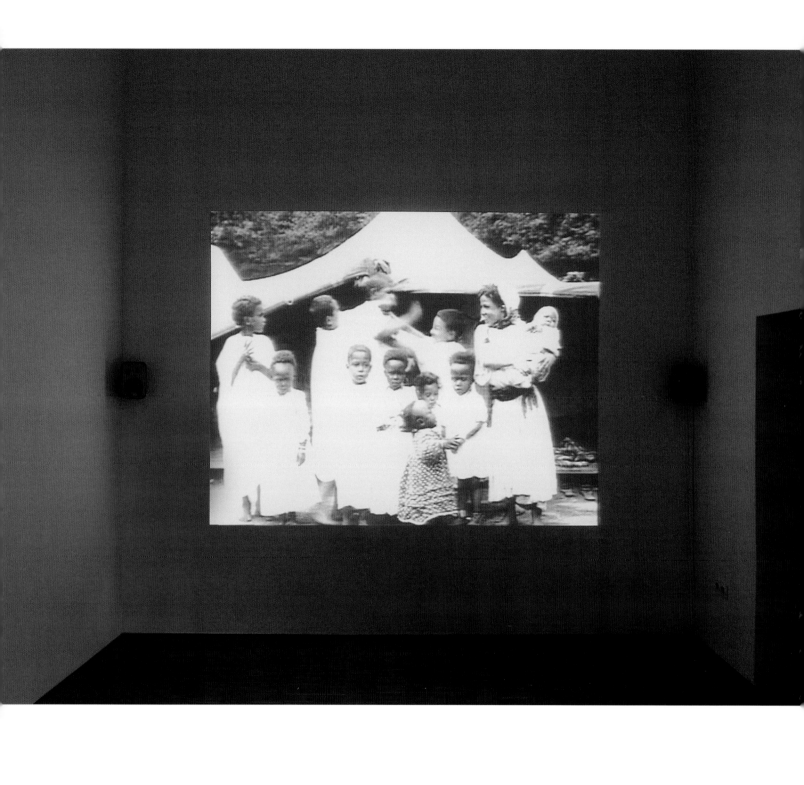

Reading the Visible and the Invisible *Tessa Jackson*

In recent years, Fiona Tan has been recognized as a prescient and significant artist. Her work has attracted a number of notable critiques, by Lynne Cooke and Brian Wallis[1] among others, which discuss how she creates her images. In deciding how to complement these in a short essay, a reflection on photography and being captured by the camera was inevitable. However, how one acts as subject, how one is complicit when in front of the camera was reinforced by an unusual event at the time of writing:

Family, friends, and colleagues were asked to be part of a commissioned group portrait by British photographer Jem Southam, as a memorial for Jeremy Rees, a pioneering figure in UK contemporary arts. We were invited to gather informally, not to line up as for a school photograph or specifically look at the camera, but to talk amongst ourselves and continue with our reminiscences. Yet we stopped conversing, instinctively turned toward the camera, and looked up expectantly, almost submissively. In fact we followed the long tradition of being drawn to the camera, performing and sublimating ourselves to its presence.

Since she was a student, Fiona Tan has been interested in the role of the camera, both still and film, in what it captures and what it triggers in our imagination. She has produced autonomous film/video works as well as documentaries, sometimes including "archive" footage within her own work. She draws upon the specific capabilities and historical use of photography and film, intricately constructing her own material with found footage to tell stories, to explore social and artistic issues, to investigate herself and her identity. Throughout she highlights the role and position of the camera, the relationship it creates between subject and viewer, reality and truth, objectivity and intimacy, memory and perception. She finds ways to remind viewers that, as witnesses, they are part of a collaboration rather than a conspiracy between object, image, context, and personal perception.

The idea of image making as part of a conversation both with oneself and with others whose origin or thinking is unknown is a construct Tan employs in *Facing Forward* (1999). The work commences with footage from an American expedition to Papua New Guinea in the early twentieth century, showing rows of men, civil and military, posing for a group photograph. The relative positioning of the Americans, "natives," and naked tribesmen is revealed as the camera moves across the scene of staring faces, making it both a commemorative photograph (of grades of officials) and an ethnographic-social document (of groupings and their relative positions). Tan chooses certain framing, certain juxtapositions

OPPOSITE
Tuareg
1999
Black-and-white video installation
Video projector, transparent projection screen, glass, 4 audio speakers, and 2 amplifiers
Projection:
5 ft 11 in. × 7 ft. 10 1/2 in. (1.8 x 2.4 m)

Facing Forward
1999
Black-and-white and tinted video projection
Transfer from 35 mm film, DVD, stereo, amplifier, and 2 hi-fi speakers
Projection: approx.
8 ft. 10 1/3 in. × 12 ft. 9 1/2 in. (2.7 × 3.9 m)
11 minutes

Facing Forward
1999

BELOW
Cradle
1998
Tinted film installation
16 mm film projector
(no rewind), tripod table
[height: 4 ft (1.2 m)],
electronic sensor/timer,
and white handkerchief
[15 3/4 in. (40 × 40 cm)]

and combines these with a sound track that heightens our awareness of history, of possible anthropological readings, and of what the camera holder was interested in recording. Through focusing on occasional details, she prompts the viewer to imagine what these men might have thought as they were "caught," even "scrutinized."

The next section of *Facing Forward* uses archive footage from the same period, but is made with a riding camera moving along streets somewhere in southeast Asia. Tracking urban activity, it provides an account of the tourist's curiosity, less impersonal and objective than in previous works. The sound track shifts to a voice-over of a hypothetical conversation between Marco Polo and Kublai Khan. The traveller is asked "You advance always with your head turned back? . . . Is what you see always behind you? . . . Does your journey take place only in the past?" Marco Polo responds to the Emperor, "Elsewhere is a negative mirror. The traveller recognizes the little that is his, discovering the much he has not had and will never have." Before the film ends and comes full circle, returning to the group photograph, Tan includes footage where the camera lingers on individual figures. As they stare back direct contact is made, fascination is exchanged. She also includes brief moments when the cameraman appears,

turning his lens on the viewer. Immediately one reflects on the respective parts played by maker and viewer: what each brings to the reading of this historical and ethnographical material, what judgements are being made about the reality. Is it inevitable that each brings his or her own cultural awareness into the dialogue? Are we brought face to face with different perspectives?

The overheard conversation between the two historically real but much mythologized figures is based upon a conversation Italo Calvino constructs in his *Invisible Cities*.[2] Marco Polo and Kublai Kahn struggle for mutual understanding and "the Venetian voyager and prodigious tale teller is characterised as knowing where he is by where he is not, what he is by what he lacks, and what exists by what can only be imagined."[3] Tan surely is proposing that this indeed may be true separately for both the image maker and the viewer. As Susan Sontag commented in 1974, "The camera makes everyone a tourist in other people's reality, and eventually in one's own."[4] Tan's work seems to subscribe to Sontag's view, restated in *Regarding the Pain of Others*, where she "dismantles the lingering and limited notion that a photograph is an objective mirror, instead of an expressive medium capable of portraying multiple realities."[5]

For *Countenance* (2002) shown at *Documenta 11* in 2002, Fiona Tan set about photographing hundreds of Berlin residents. Finally shown in the format of two adjacent

spaces with four projections, two hundred barely moving faces stare directly at the camera and viewer. In this work Tan consciously echoes the German photographer August Sander (1876–1964), who embarked on a lifelong project documenting "Man of the Twentieth Century." He was of the view that "people are formed by the light and air, by their inherited traits, and their actions. We can tell from appearance the work someone does or does not do; we can read in his face whether he is happy or troubled."[6] Starting in the 1920s he photographed more than six hundred people from all walks of life, creating a memorable typological catalogue. Similarly, Tan's moving images are direct and perspicacious, with the camera remaining on her subjects' open faces for some considerable time. As a viewer one imagines who they are and the lives they might lead, but above all why and how one concludes on a certain description for each model. In the context of the nineteenth-century fascination with physiognomy and physical psychology *Countenance* possesses an added tension. As artist Craigie Horsfield has commented,

> It is an impossibly painful thing to realise that the lives, the very existence of people one loves are of the same matter as their fathers and mothers, and generations before. . . . To embrace such an understanding of history forces us to confront what I might call the genealogical, the matter of our own being in relation to the physical matter of our friends. And that history exists in the most visceral, most sensational of ways. . . . It no longer says that I am the centre, and the future is all that awaits me, it says that I am of a piece and of a kind with those who were my forebears. Photography may precisely engage with that apprehension. This is what makes it uncomfortable.[7]

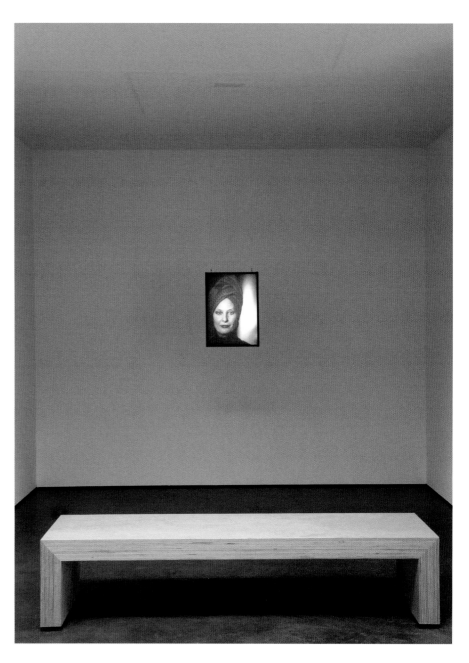

ABOVE AND
PAGES 12 AND 13
Countenance
2002
Tinted video installation
4 video projectors, 5 hifi audio
speakers
Room 1, screen: 23 $3/5$ × 17 $1/3$ in.
(60 × 44 cm)
Room 2, 3 translucent projection
screens: 74 $4/5$ × 55 $9/10$ in.
(190 × 142 cm)

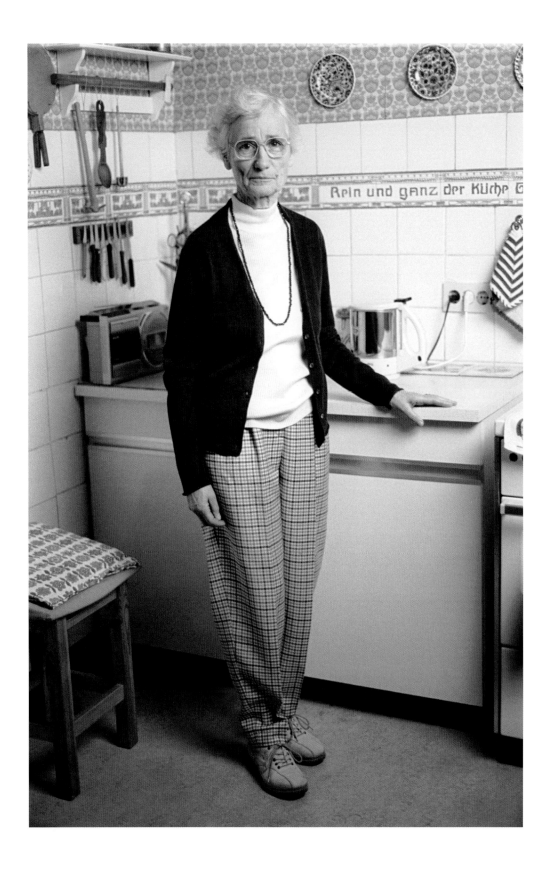

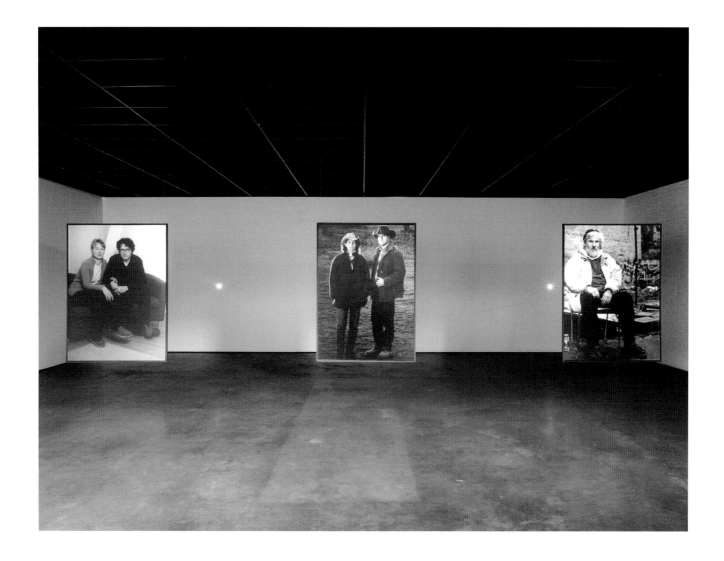

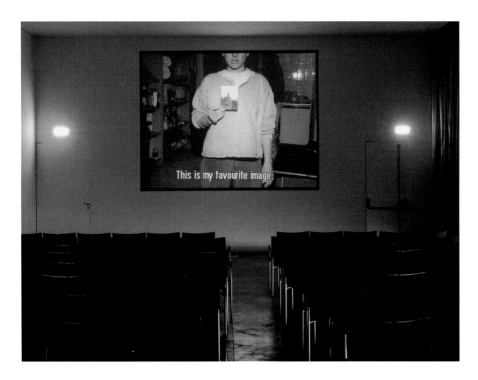

This is my favourite image.

Kingdom of Shadows
2000
Black-and-white and color
documentary film
Digital betacam, stereo, with
versions in English, French,
and Dutch
50 minutes

RIGHT
**May You Live in
Interesting Times**
1997
Color documentary film
Digital betacam, stereo, with
versions in English and Dutch
60 minutes

Throughout her work Tan turns the camera briefly upon herself. In *Linneaus' Flower Clock* (1998, p. 16), an intimate love letter, she appears by looking at the camera directly, at different times of day and in a variety of settings. In the context of the work one imagines she uses this construct to act as a lexicon of memory, providing reminders of the personal relationship on which the work is based, by visualizing who and what she was at that time. It also emphasizes the relationship between subject, viewer, and author. In Tan's notes for the experimental documentary film *Kingdom of Shadows* (2000), which appear in the publication *Scenario*, Esma Moukhtar reminds us that "Pictures make it possible to hold on to our memories, to events or to people who are dear to us."[8] *Linneaus' Flower Clock,* as much of Tan's work, is autobiographical and connects to particular ideas that affect her. Her work moves backward and forward

from documentary to fiction, biography to imagination; she has noted: "It's become clear to me that I often expressly work from within myself, and for that reason I'm often in the picture. The films are about things that affect me personally, things I want to investigate." Tan constantly pushes her understanding of herself in the world, and as artist acts as agent provocateur, mentor, and conscience to both herself and her viewer.

In *May You Live in Interesting Times* (1997) Tan makes a physical and psychological journey to find out who she is. In the voice-over she admits early on that in setting herself this task, it "started as a search" and then she admits she "constantly feels in search" of her search. With an Indonesian-Chinese father and an Australian mother of Anglo-Saxon descent, brought up for the most part in Australia and now living in the Netherlands, Tan has charted her journey in her work to find out whether she has lost part of herself in changing languages, customs, and countries; what cultures does

she have inside herself and to what degree does she feel Chinese? The film is cleverly composed of interviews from paternal family members now based across the globe, personal admissions, and descriptions by her subjects as to who they feel they are. The piece moves from Tan jokingly admitting she feels a "professional foreigner" to responses by others to her question as to whether she is Chinese. She finally concludes, "my self definition seems an impossibility. An identity defined only by what it is not."

Tan's new work *Correction* (2004) prompts one to reflect on how photography and film have been and are used as social and anthropological tools, and what the camera reveals of its individual subjects. Her subjects here cannot escape their relationship to each other, to their context, or indeed to Tan herself. Yet this is a unique opportunity for them to live in a range of realities as boy/girl, man/woman, son/daughter, father/mother, husband/wife, lover, neighbor, or friend. Fiona Tan is only too aware that "it is true that the camera, photographs and films, show us things in a different way and things we sometimes could not otherwise see."[9]

Tessa Jackson is the Founding Artistic Director of the Artes Mundi Prize, a new international visual art prize emanating from Wales for which Fiona Tan was shortlisted.

Notes

1 See Lynne Cooke's essay in *Scenario–Fiona Tan* (Amsterdam: Vandenberg & Wallroth, 2000) and Brian Wallis's essay in *Artes Mundi Prize 2004* (Artes Mundi in association with Seren, 2004).

2 Italo Calvino, *Invisible Cities* (1972) (Orlando, Florida: Harcourt, 1974).

3 Cooke (note 1).

4 Susan Sontag, *The New York Review of Books* 21, no. 6 (April 18, 1974).

5 Robert Hirsch in his review of Susan Sontag's *Regarding the Pain of Others, Photovision: The Art & Technique of Photography* 3, no. 5.

6 August Sander, *Confession of Faith in Photography*, 1927.

7 Craigie Horsfield, in *Craigie Horsfield,* exh. cat. (London: Institute of Contemporary Art, 1991).

8 Esma Moukhtar, in *Scenario–Fiona Tan* (note 1).

9 Fiona Tan in a letter to John Berger, December 1999 published in *Scenario–Fiona Tan* (note 1).

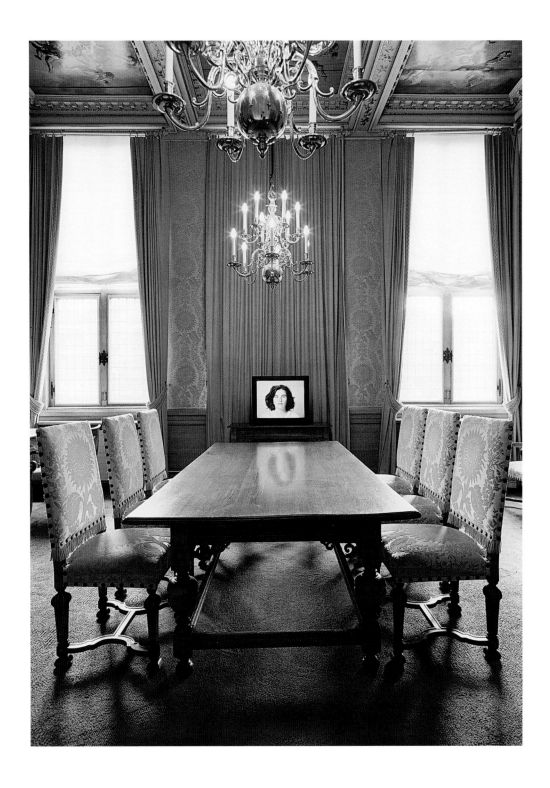

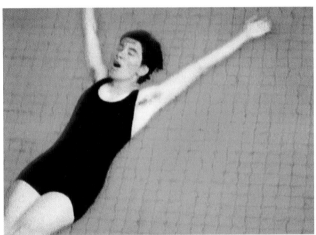
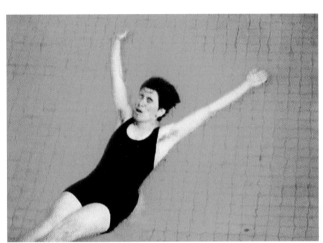

ABOVE AND OPPOSITE
Linneaus' Flower Clock
1998
Tinted and color video
DVD, stereo
17 minutes

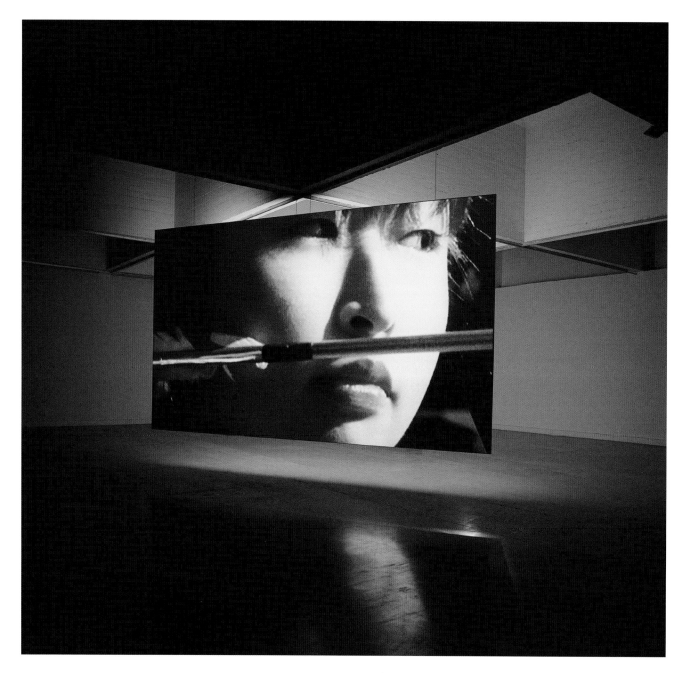

Saint Sebastian
2001
Color video installation
2 wxga video projectors,
2 DVD players, 2 amplifiers,
and 8 hi-fi audio speakers
White, double-sided projection
screen [approx. 14 ft. × 7 ft. 10 in
(4.25 x 2.39 m)]

Marebito
2001
Artist's book
Offset color and black and white
13 × 9 × 3/5 in. (33 × 23 × 1.5 cm)

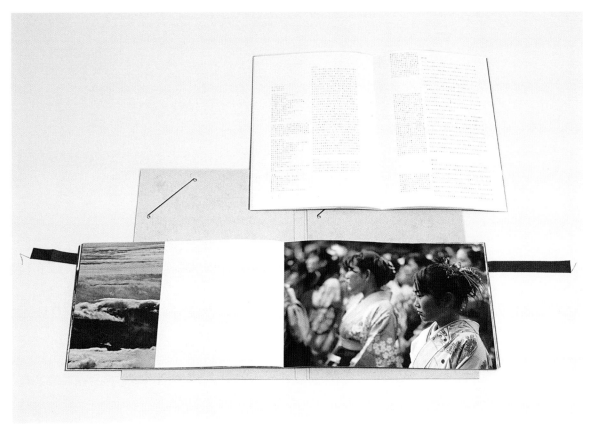

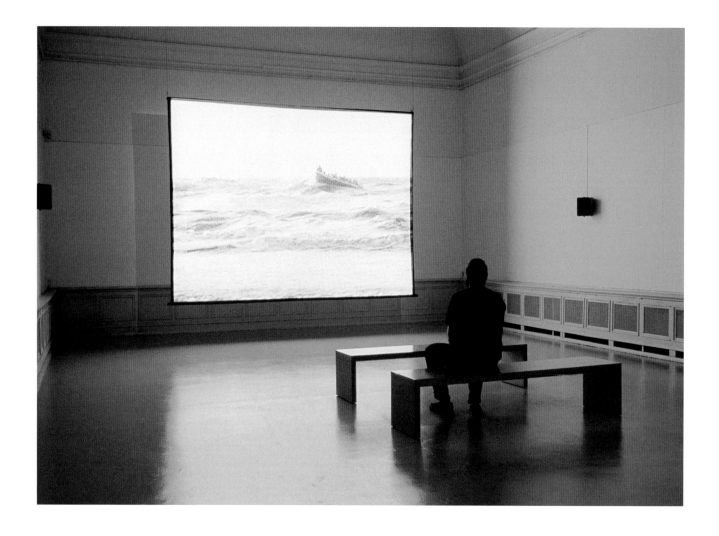

ABOVE AND OPPOSITE
News from the Near Future
2003
Tinted video projection
Video projector, DVD player,
stereo amplifier, and 2 stereo
hi-fi speakers
Projection:
min. 13 ft. 1 1/2 in. × 9 ft. 10 in.
(4 × 3 m)

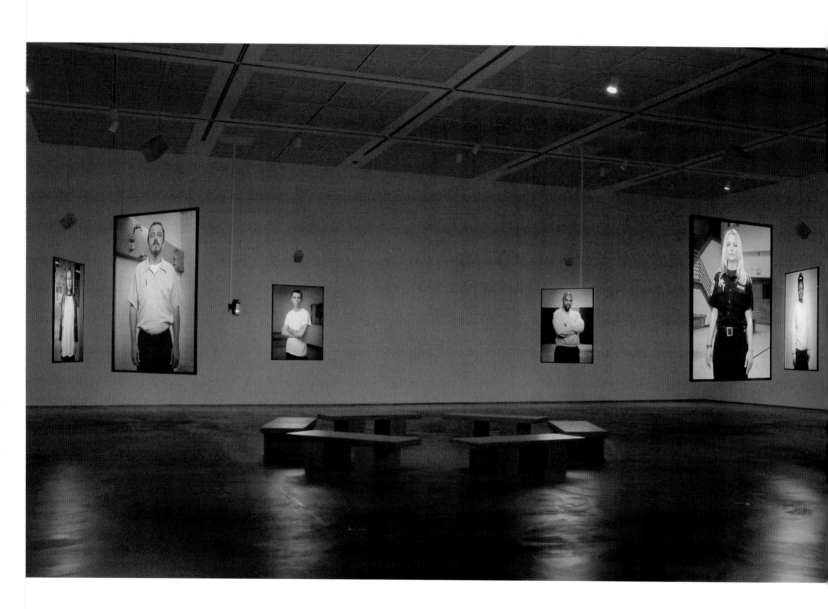

Setting the Record Straight: Fiona Tan's *Correction* *Joel Snyder*

All my work reflects on and relies heavily on documentary principles of filmmaking. . . . Similarly, nearly all my film and video installations — whether filmed by myself or using existing footage — incorporate material of a documentary nature. I am interested in film, video, and photography viewed from its recording, documentary, and anthropological viewpoint.

— Fiona Tan, 2002

Fiona Tan's international reputation as a film and video artist is grounded in her fascination with representational practices that promise to give us a certain kind of knowledge, but which in the end fail to provide us with it, or with an understanding of the world, or of ourselves. The practices of photographic and film documentary production are easy to describe, but the ends they serve are obscure. The historic ethnographic films Tan has used brilliantly in her installations (*Facing Forward* [1999, see illustrations on pp. 8 and 10] comes to mind) seem to give us knowledge of unfamiliar human types in far-away places, but looked at in a different way, they reveal much more about presuppositions of those who made the films than they do of the lives of the people they portray. Tan's devotion to "documentary principles of filmmaking" points simultaneously in two directions, allowing her to adopt the formal packaging of disinterested recording or documentary while at the same time denying

and undermining the possibility of such record making. As she both employs and subverts documentary practices and products, she reveals something of the way in which record-making and record-keeping function to maintain and extend our notions of knowing by seeing, of comprehending by merely looking. Documentary pictures, whether moving or still, do not passively reflect or record the world. They transmit to those who view them the principles and prejudices of those who make them.

Portraits of prisoners, c. 1880
Photographer unknown

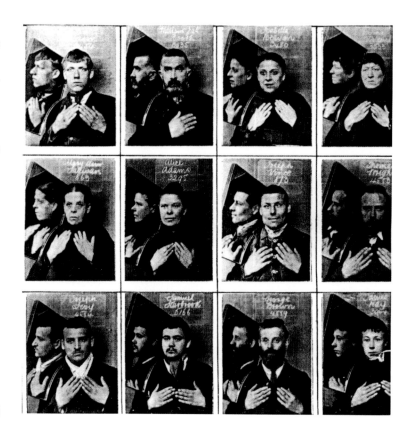

Correction occupies the second-floor south gallery of the Museum of Contemporary Art, a room measuring 76 feet along each wall. Within this space, six screens, each measuring 3.6 feet by 4.9 feet, are suspended from the ceiling, their bottom edges hanging 3.9 feet above the floor, at intervals of roughly 17 feet, providing six points of a circle with a diameter of 40 feet and a circumference of 125 feet. Six digital video projectors, each targeted on a single screen, are mounted to poles and locked into position 7.2 feet above the floor. The projectors stand outside the circle facing inward. The projected images can be viewed from either side of the screen (a viewer on one side sees a reversed image of what can be seen on the other). A speaker is installed 1.8 feet above each screen. Each projector is fed a unique sequence of video clips and recorded sound contained on one of six DVDs. None of the images projected on any given screen is shown on any of the others. Each shot in the six series is projected for from 20 to 50 seconds; to see every image in the installation requires roughly three hours. The DVD players are not synchronized. Six benches measuring 4 x 1.6 x 1.5 feet are arranged in a hexagon within the circle traced by the screens. Spectators are free to view the installation seated on the benches or while walking outside or within the circle. The room is darkened, with overhead lights washing gently on the external walls.

The 300 video clips of prisoners and guards in four prisons in Illinois and California, filmed in 2004, are presented together with the sounds recorded simultaneously with their production. The installation is frankly political — meaning not only that its substance is drawn from the representation of the uses of power on those who are subjected to it, but also that it provokes analysis of how and against whom that power is marshaled. Fiona Tan reports that the idea for the installation was triggered by reading an article about the rapid growth of the prison population in the United States during the past forty or so years. In her brief remarks in this catalogue (p. 31), she writes: "While in the late 1960s the population of inmates in American prisons numbered close to two hundred thousand, this number now exceeds 2.2 million. That is more than any other country, and represents a quarter of all prisoners worldwide." These appalling numbers continue to grow. In late 2003 the annual summary report distributed by the Bureau of Justice Statistics of the United States Department of Justice stated that there were an estimated 480 prison inmates per 100,000 U.S. residents — up from 411 at the close of 1995. The report also provided a breakdown of the racial mix of the prison population, noting that by "midyear 2003 there were 4,834 black male prisoners per 100,000 black males in the United States in prison or jail, compared to 1,778 Hispanic male inmates per 100,000 Hispanic males, and 681 white male inmates per 100,000 white males."

The title *Correction* is equivocal. It alludes to the way we have, in this country, come to package our thoughts about the goals of imprisonment — not vindictive punishment, but correction, not imprisonment, but corrective treatment. It refers also to the names of the governmental agencies that manage "houses of correction," state departments of correction. But it is also meant ironically, as a protest — as if the artist was shouting at her audience, "Correction!" demanding that this policy of ever-expanding imprisonment be subjected to immediate review and change.

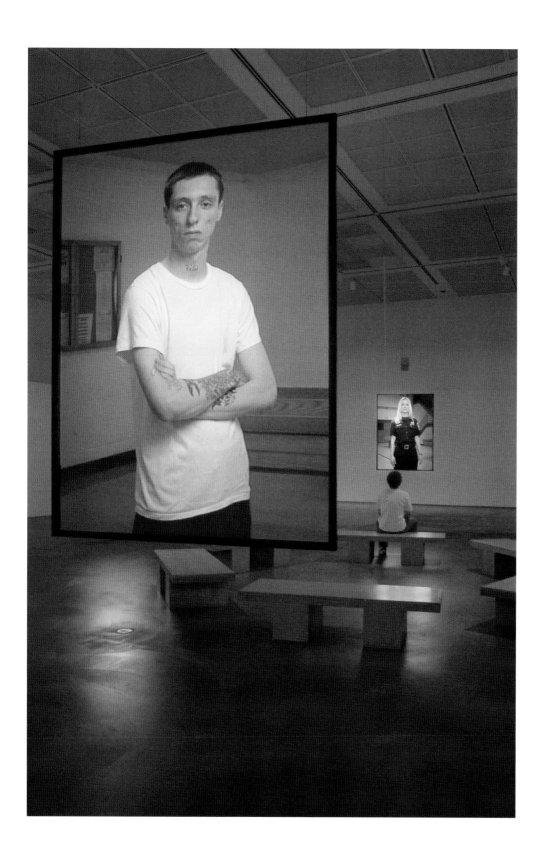

Upon entering the installation space, a visitor hears sounds coming from speakers that are arranged in a slightly off-center circle within the large gallery. The sounds are not noise, or not only noise; they carry distant, muffled, human voices speaking words that are mostly devoid of meaning. These are not, strictly speaking, sounds heard in a prison, but are sounds recorded in jails by a machine that obeys its instructions to amplify all sounds without respect to their origins — the droning hum of ventilation fans, the play of human voices, the thudding of footsteps, the slamming of doors — all are given equal weight, all are accorded equal respect by the machine, whether or not they deserve it. These acoustic recordings are also documentary, but they cannot provide us with the experience of standing in a prison and listening, straining to make sense of what can be heard; they are the artifacts of electronic recording. And each recording, spilling out of its own speaker, hums, pulsates, and hovers at the ear where it merges into five other sound tracks.

Standing at the entryway to the installation it seems that the screens are covered with projected, still, color photographs that change from time to time, approximating the look of 35mm transparencies thrown at a screen by a Carousel projector. But as the viewer approaches the screens, it becomes apparent that each picture is not lifeless. The subject moves involuntarily, against his or her own will, or rocks ever so slightly back and forth, performing an ancient photographic ritual (one that dates to the late 1830s) of attempting to become a still life (the French would say *nature morte*) in front of a camera, of straining to suppress all signs of life while sitting or standing for a portrait photograph. Tan entered into an agreement with prisoners and guards who volunteered to stand still for fifty seconds in front of her video camera. She used the camera, which was designed to show people and things in motion, in the service of producing ever so slightly moving pictures. Constrained by the need to stand still for what must feel like an unbearable length of time, her subjects strain to suppress all movement, all signs of life — and because they are human, they fail.

Tan's video clips violate a built-in necessity of moving-picture technology. Film and video cameras are designed to produce pictures in horizontal formats (that is, images that are wider than they are tall), which are intended, in turn, to be projected horizontally. But Tan orients her video camera perpendicularly to the ground, so as to produce filmed portraits that are taller than they are wide and, in turn, uses a vertically aligned projector to exhibit them, producing a format that is foreign to moving pictures. The result is a vertical, moving portrait of a constrained, barely animated human subject — a pictorial metaphor for the inhuman effects of imprisonment. These pictures show what we otherwise could not see — the loss of motility, of animation, of an indispensable condition of life. Why should we expect this loss to result in correction?

Tan's video clips are intermediate pictures, hybrids that in many ways look like magazine illustrations, full-page, frozen photographic portraits made by skilled professional photographers for fashionable, high-end magazines. But unlike magazine portraits, these pictures show undersized signs of life that have been magnified for us by projection. The projectors enlarge these prisoners and guards, presenting them to us literally as bigger than life, and so every small movement they make is

exaggerated, and we see them as if viewed through telescope from a few feet away.

Correction relies on auditory and visual intensification achieved through two distinct types of augmentation: amplification of remote, unintelligible human sounds, and magnification of small, involuntary human movements. The tools Tan employs in its production and presentation create a figurative medium for representing the horrifying, dehumanizing effects (on both the guarded and the guards) of the equipment and procedures of incarceration. This figuring of incarceration is not meant to give us a vicarious experience of imprisonment (as if anything but being imprisoned could force us to live the life of a prisoner) any more than it is meant to romanticize or aestheticize prisoners or prisons. The installation allows us to look beyond looking, to study, by way of magnification, visualizations of constraint, confinement, suffocating enclosure. Correction is a profound meditation on contemporary American values and habits of thought. It is also, not coincidentally, a deeply moving work of art.

Joel Snyder is a professor in the Department of Art History at the University of Chicago and is coeditor of the journal Critical Inquiry.

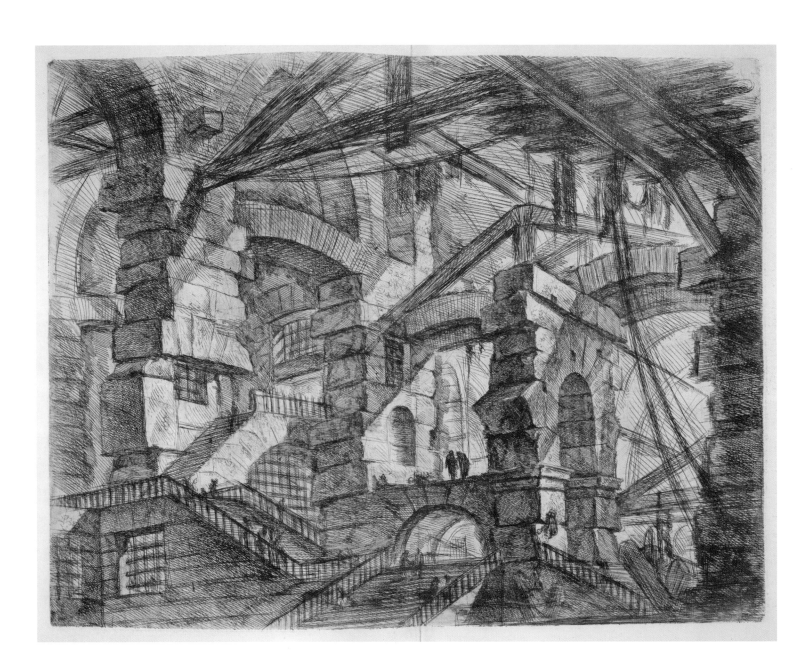

Carceri d'Invenzione *Fiona Tan*

While in the late 1960s the population of inmates in American prisons numbered close to two hundred thousand, this number now exceeds 2.2 million. That is more than any other country and represents a quarter of all prisoners worldwide. In the last decade, more than 350 new prisons have been built and more than half a million beds added to existing facilities.

Correction offers a small survey and sample of the current penal population of America. In four penitentiary institutions in the states of California and Illinois inmates and officers were approached and took part in the filming of this project entirely on a voluntary basis. More than three hundred portraits were filmed in the summer of 2004. All the people seen in the video installation are either prisoners or prison guards.

The misery of gaols is not half their evil. . . . In a prison the awe of the publick eye is lost, and the power of the law is spent; there are few fears, there are no blushes. The lewd inflame the lewd, the audacious harden the audacious. Everyone fortifies himself as he can against his own sensibility, endeavours to practice on others the arts which are practised upon himself, and gains the kindness of his associated by similitude of manners. Thus some sink amidst their misery, and others survive only to propagate villainy.

— Samuel Johnson, *The Idler*
(1759)

You cannot meet a prison population; you can only meet persons.

— Pierre Raphael,
Inside Rikers Island

Carceri d'Invenzione
(Imaginary Prison)
Giovanni Battista Piranesi
Opere varie di architettura
prospettive, grotteschi antichitáa
Romani, 1750
Courtesy of the Division of Rare
and Manuscript Collections,
Cornell University Library

Prisons, as we know them, have existed for about 250 years. Before then, they were for the most part dungeons where criminal offenders were held before receiving punishment.

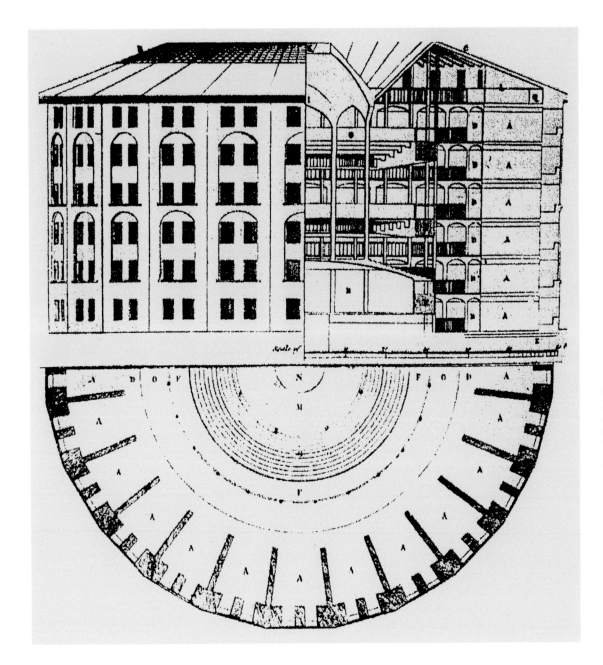

Bentham's Panopticon (1791)

Jeremy Bentham was an English lawyer who advocated a more effective penal system. This architectural model embodied a clever form of centralized surveillance and far-reaching isolation. Foucault described the Panopticon as a "seeing machine." Indeed Bentham himself described his Panopticon as "a new mode of obtaining power, power of mind over mind, in a quantity hitherto without example."

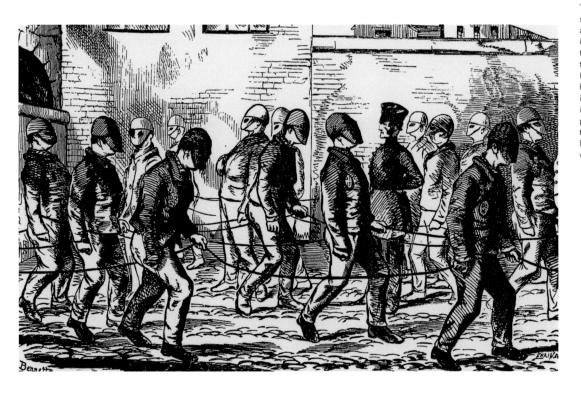

The exercise yard at Pentonville Prison (1862)

This prison was run upon the so-called Philadelphian plan, a model based on the Quaker ideas that isolation and solitude would automatically lead to spiritual improvement. Inmates were subjected to a harsh regime of twenty-four-hour isolation; the hoods served to isolate prisoners in each other's presence. Prisoners developed their own clandestine sign language and even a form of ventriloquism.

Aerial view of Eastern State Penitentiary, Philadelphia (1856)
Image courtesy of Eastern State Penitentiary Historic Site, Philadelphia

The world's first panoptic prison, built in the first half of the nineteenth century. In 1842 Charles Dickens visited the Eastern State Penitentiary in Philadelphia and denounced what he saw as a "secret punishment," which was "immeasurably worse than any torture of the body."

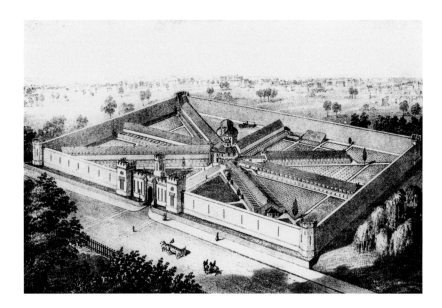

I think there was even an ad by a phone company promoting prison telephone service, which was like this: "How he got in is your business. How he gets out is ours." When I think about all of this I feel kind of optimistic, like my life is not wasted inside this dungeon. We don't want to be rehabilitated and they don't intend that when they put a hood on your head, once they throw you in isolation. People were scandalized by the images of prisoners in Iraq brutalized by American soldiers. They should have a look at video from some correctional facilities in Texas; it looks as if the soldiers staged a remake of those tapes. To be in charge of punishment seems to give people an extraordinary power. To punish you need to be convinced you will never be punished and when you cross that threshold, you can be transformed into a very nasty person. To lock anybody into a space slightly bigger than a coffin, as it is in lockdown, you need to fear that the roles will never be reversed, because if the idea of yourself inside that hole crossed your mind, you would think twice before you even consider it a possibility for another human being. Someone told me that in maximum security prisons you can spend your time in a tiny metal cell for years on end. Whoever emerges from this situation is not a person, and whatever they have become, you don't want to meet them either inside or outside. Why we do this to ourselves, as a civilized country, God only knows, yet we do it and eventually we will face the consequences of this strange experiment in breeding global massive rage.

In the past there was an idea that if you remained long enough with your soul, you would make it better; if your soul was rotten you need to confront it much longer. Whoever had this theory never realized that if the only example you have in isolation is the demons of your mind, then it is very likely that your soul will not heal at all but will turn into pure, ruthless evil. It is a fact that the majority of inmates that go in with lesser crimes and are subject to isolation turn out as murderers. I read a very interesting article about this by Sasha Abramsky in an old issue of the *Atlantic Monthly* I found in the prison library. The title was "When They Get Out." It presented an apocalyptic vision of all these inmates who turn into murderers that will be released, hundreds of thousands in the next ten years. You know some of us arrive at the prisons disturbed and some come out crazy. Because you lose any sense of time, and you forget the nature of your crimes and even your individual nature, killing does not seem to be such a bad option. Life is a time-based matter, and if you don't have a concept of time, life in itself, your own and that of others, seems irrelevant. You can say that my view of the correctional system in the U.S. is not objective and that my reflections are maimed by a latent conflict of interest. Yet, as I said at the beginning, I believe that focusing on internal time, that particular kind of time we experience inside, allowed me to become a better person and to see my punishment as an opportunity for improvement rather than decay.

Not everything I learned here about prisons is totally grim. I had the chance to study the early architecture of prisons, beginning with an experiment by Jeremy Bentham, a lawyer, who conceived the idea of the "panopticon" in 1791. In the middle of the nineteenth century, the first panopticon prison was built in Philadelphia. In this kind of prison inmates could be isolated and still observed by the guards around the clock. The interaction between freedom and captivity was reduced to a minimum.

The guards could control the prisoners without almost ever coming into contact with them. To be able to see without being seen enhances one's sense of freedom. Security cameras do that today, but in the panopticon the guards' presence, without the contact, inside the same architecture that gave guards a new feeling of power, while the prisoners began to feel like a herd. Today's architects seem to be uninterested in prison architecture. They design stores, museums, libraries, private homes, Olympic Stadiums, and swimming pools, but not prisons. A prison is something good architects seem to ignore, and yet they talk about flows, synergies, and systems and theorize ugliness as a necessity to be faced by architecture — all issues that belong very much to the nature and the life of a prison. Why aren't they interested in structures that, in the U.S., host almost two million people and produce a substantial economy? I guess that as a social subject we remain marginal, residues of a culture that worships visibility rather and invisibility and invisible we truly are.

A young Dutch artist has traveled to the U.S. to film us. I don't know exactly what she will have in mind, but I appreciate the idea that someone thinks we are worth seeing, to be taken out of our forced but productive invisibility. They asked me if I would like to be filmed by her and I passed on the offer. Not that I was against the idea, but I don't need to be thinking about the outside, I need to concentrate on here. She will film three hundred people, and that's enough to show that we are not simply transformed into numbers. The gaze of my colleagues in her camera and eventually into the eyes of the beholder will be a way to convey a new kind of freedom, a symbolic freedom that is nevertheless very important. To be in front of a camera is also to be in a certain way in front of the real world, a chance to grasp our own pride again, a pride that has been crushed but not destroyed. There is nothing exploitative in trying to understand, through the simple process of filming, the nature of someone else's state of mind, his or her reality, the nature of their despair. The Dutch knew how to paint very beautiful still lives, and in a certain way the idea of filming people in prisons is another way to create a still life. The people in the camera do not seem to have a real life; like fruits in bowls they are there simply to represent a moment in time that has been extended endlessly. When you serve time, your life stands still as long as you are inside. The life we live here is not real life, it's organized, like those objects and fruits in seventeenth-century canvases, very carefully, if not so beautifully. It is not life and yet we are still living in an abnormal state of suspension. We belong to society, we are its property. Society needs us to remember why freedom exists. In filming any of us the director remembers her freedom but at the same time she reminds us that freedom still exists, if only in the short space between our gaze and the lenses, in that fragment of time when the camera is running, allowing our soul to take the only chance to escape, leaving behind just a body with a number and a mind wishing to be born into another life.

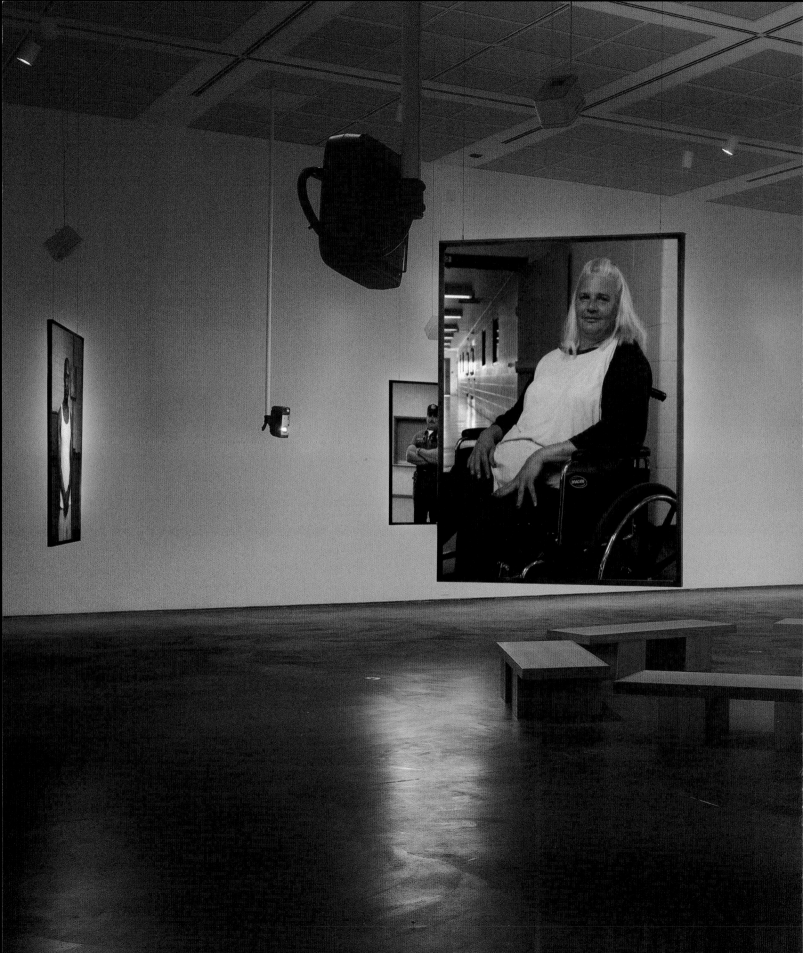

Correction

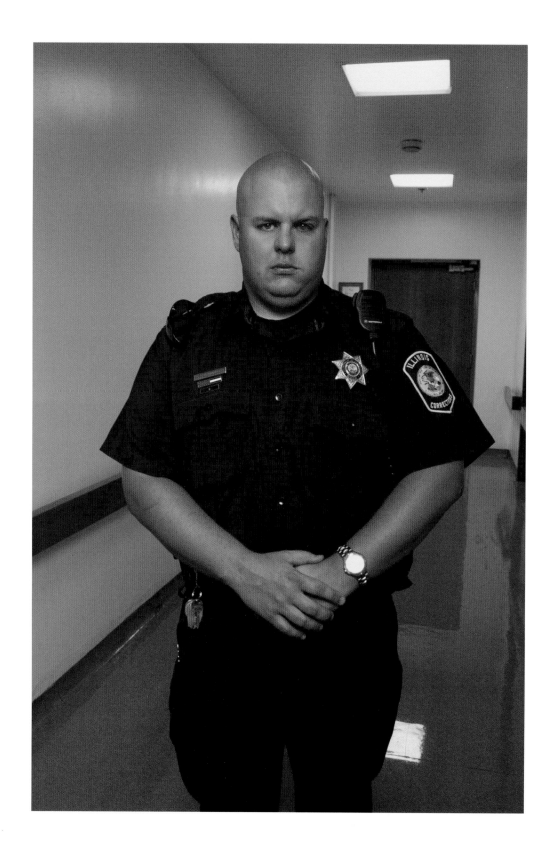

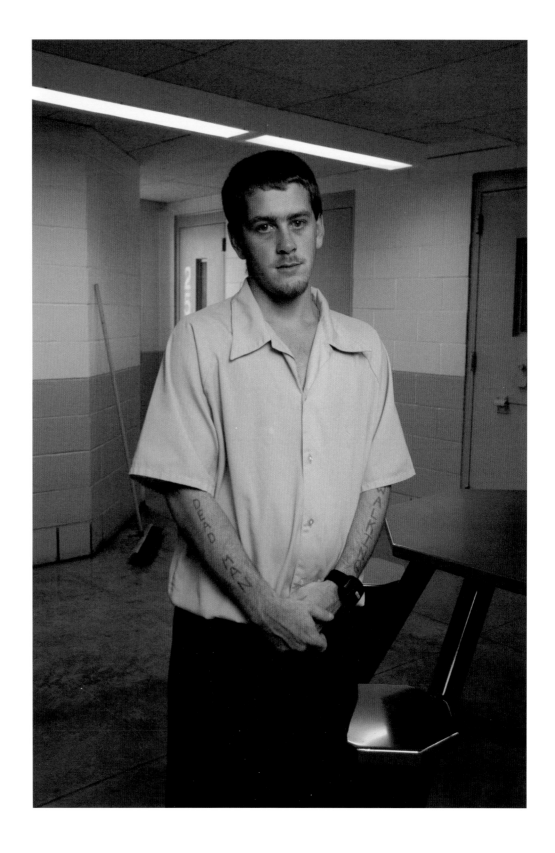

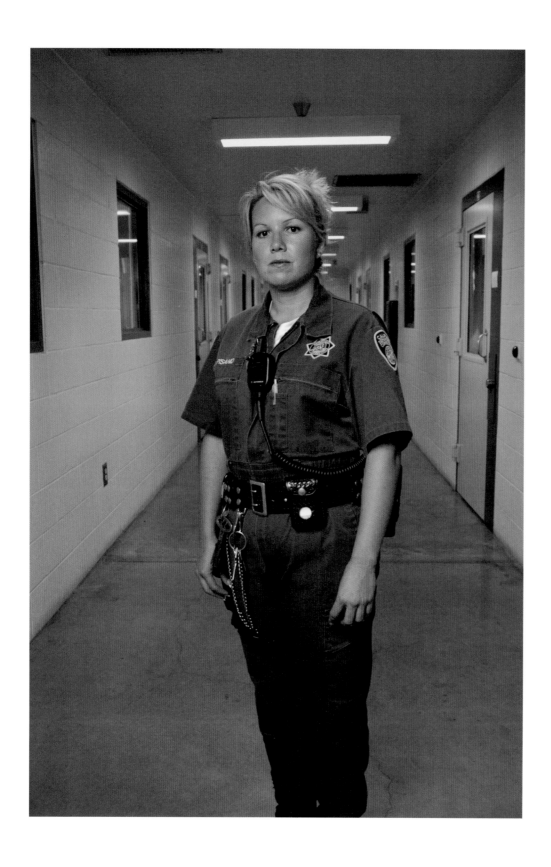

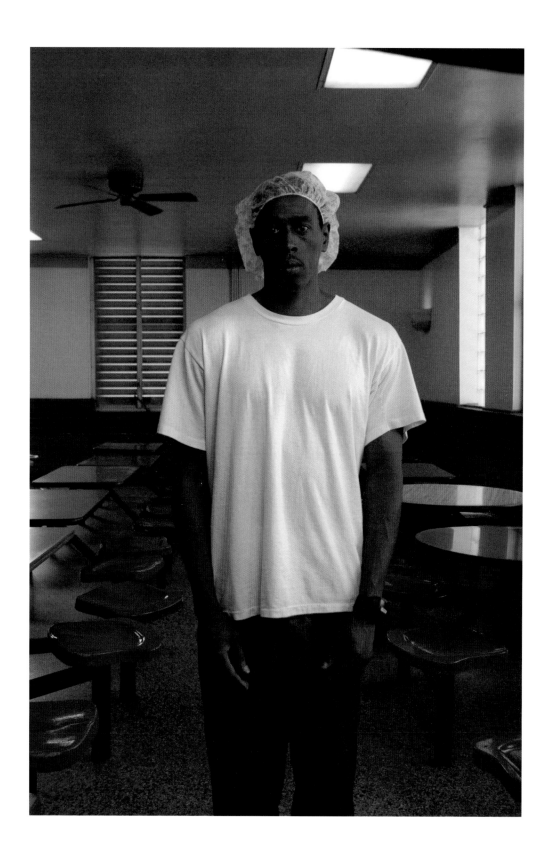

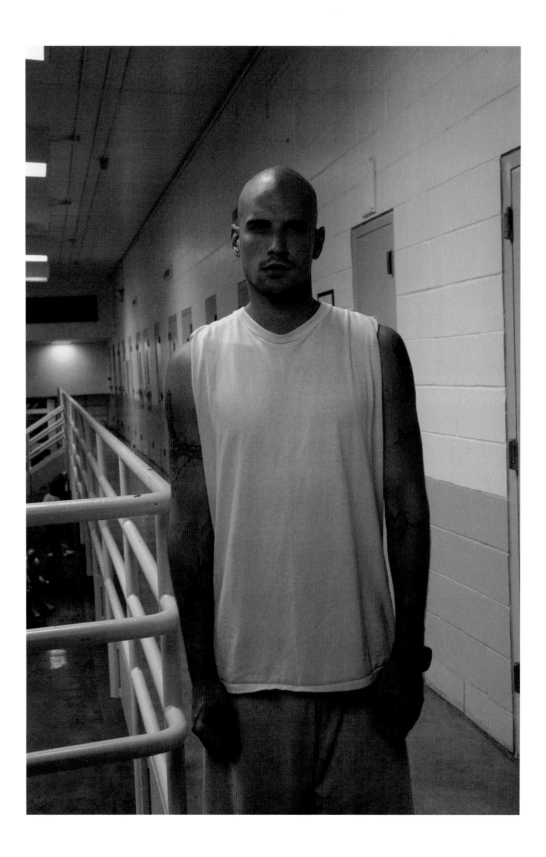

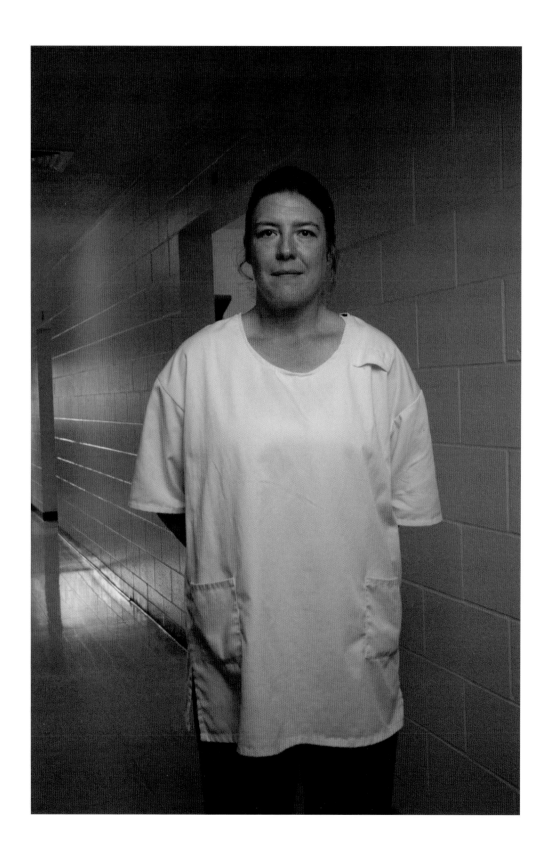

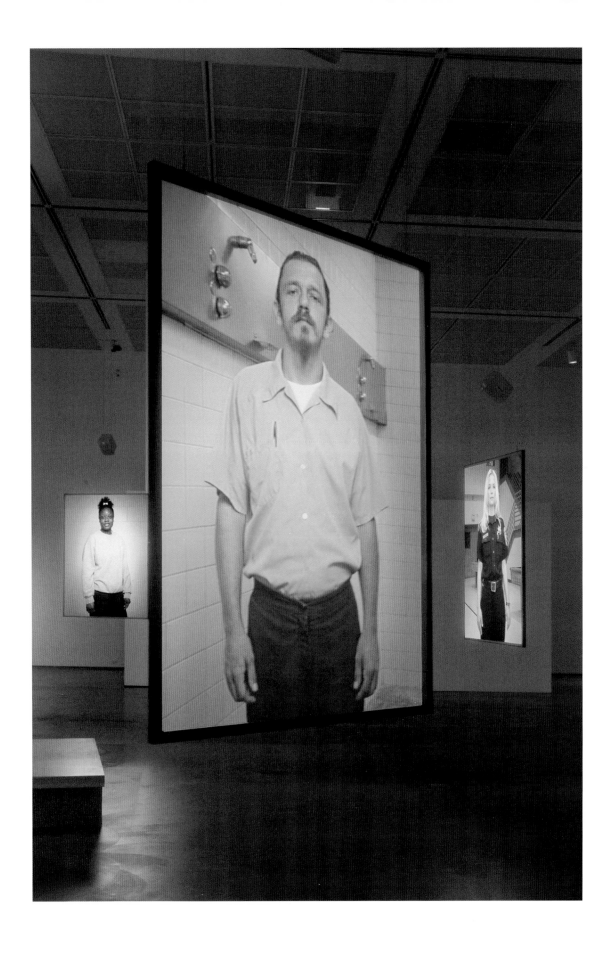

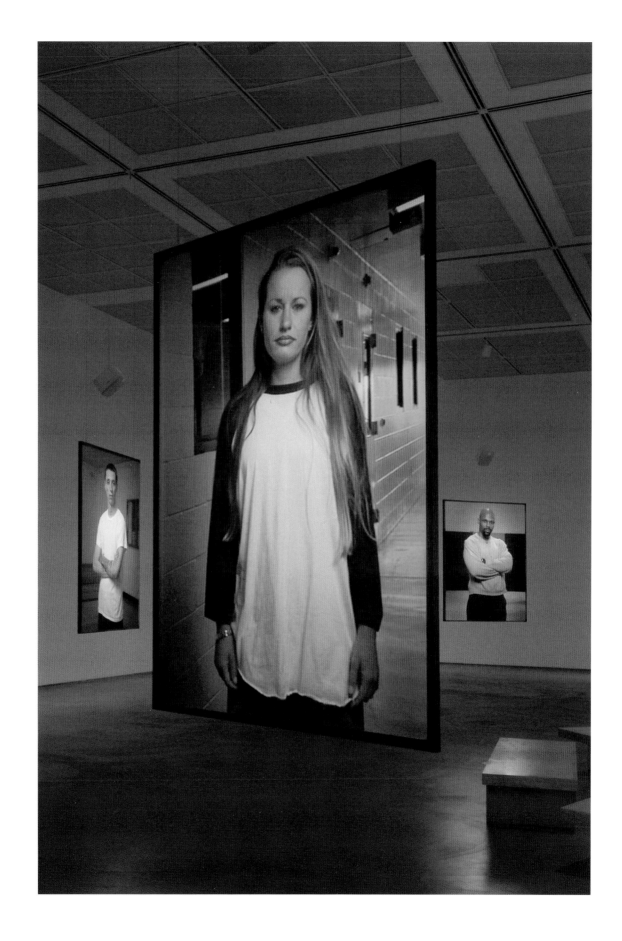

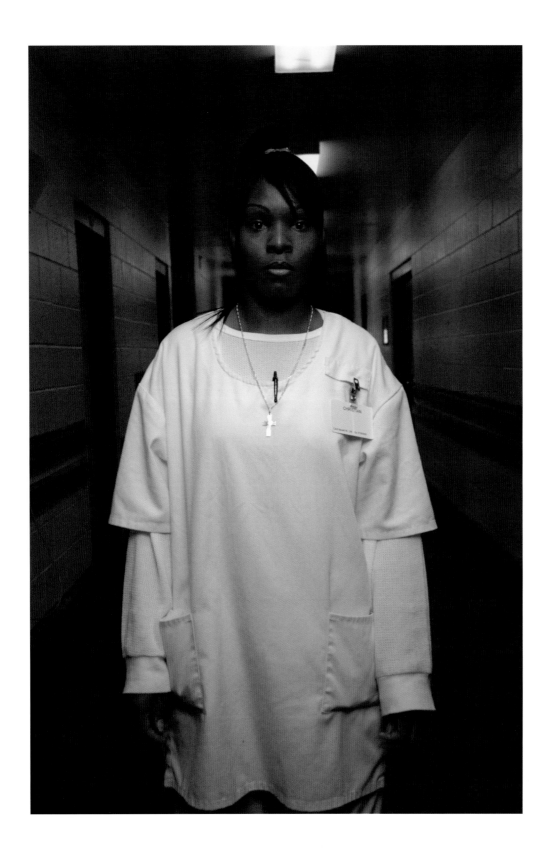

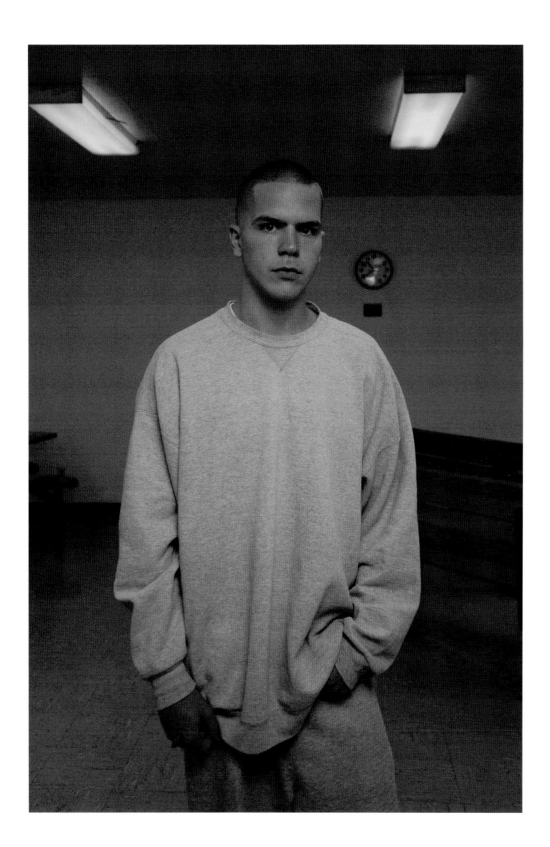

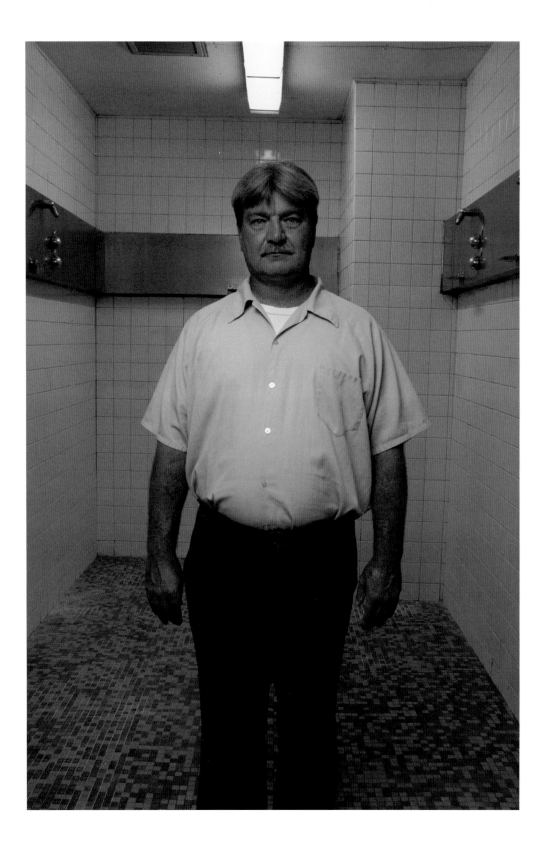

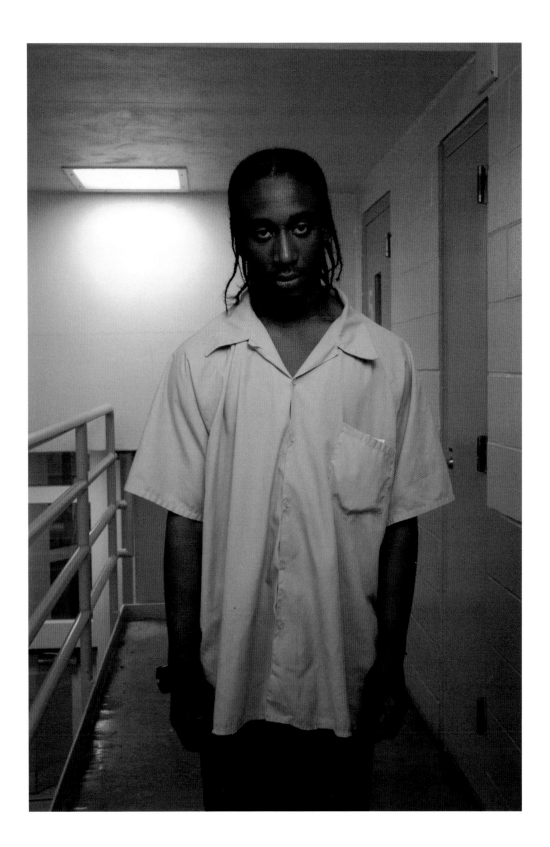

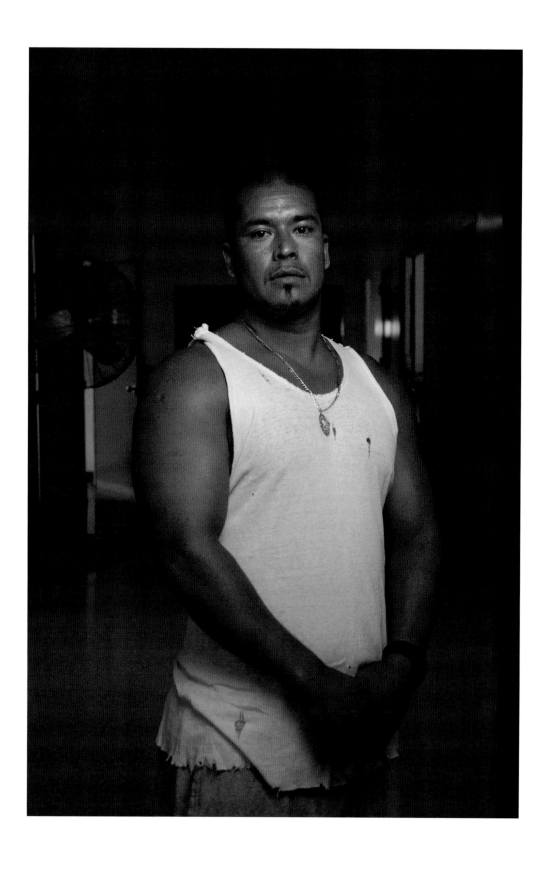

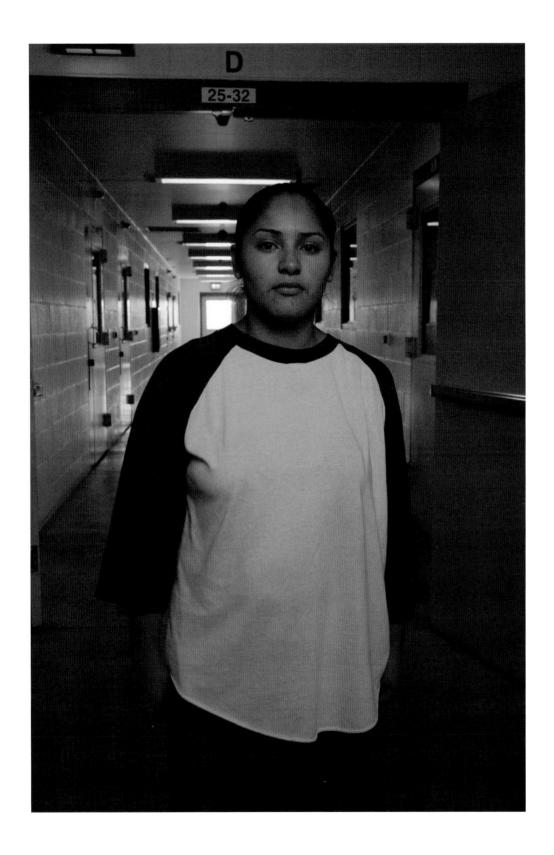

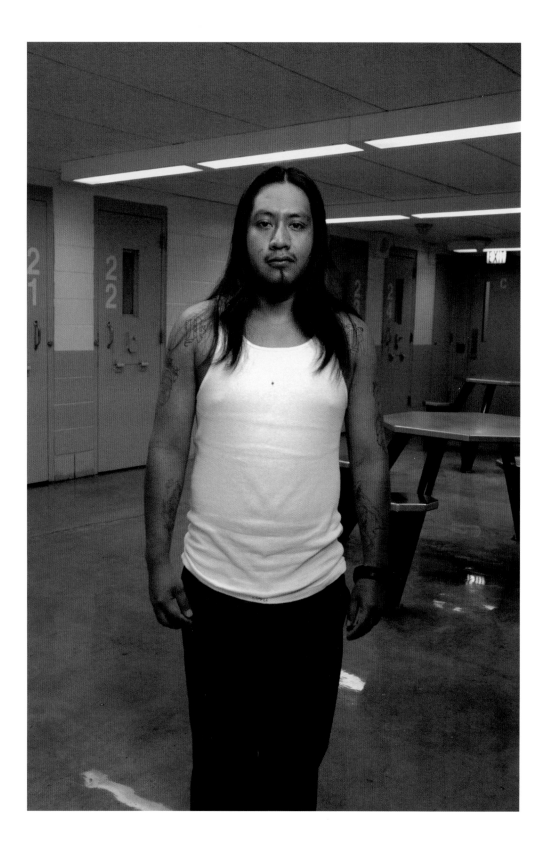

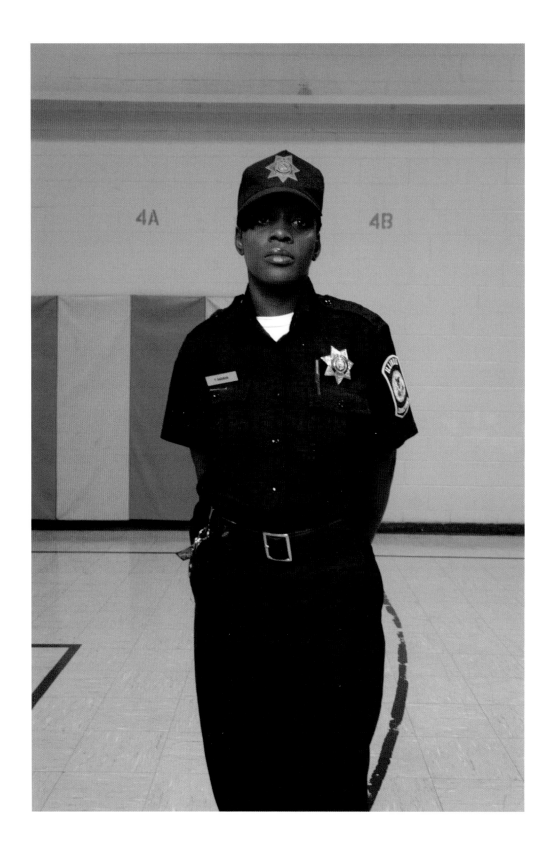

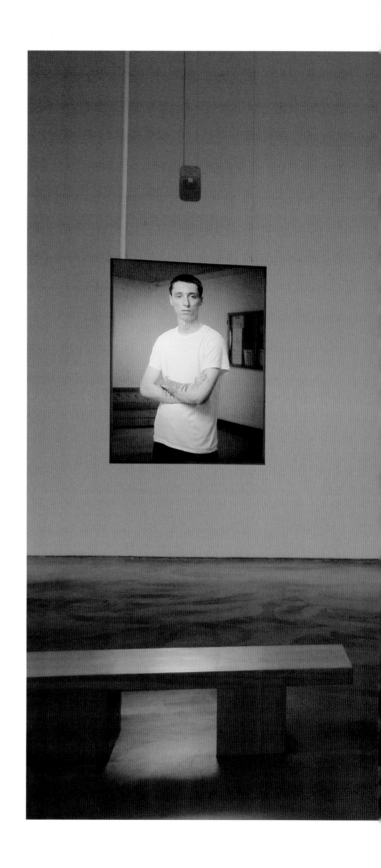

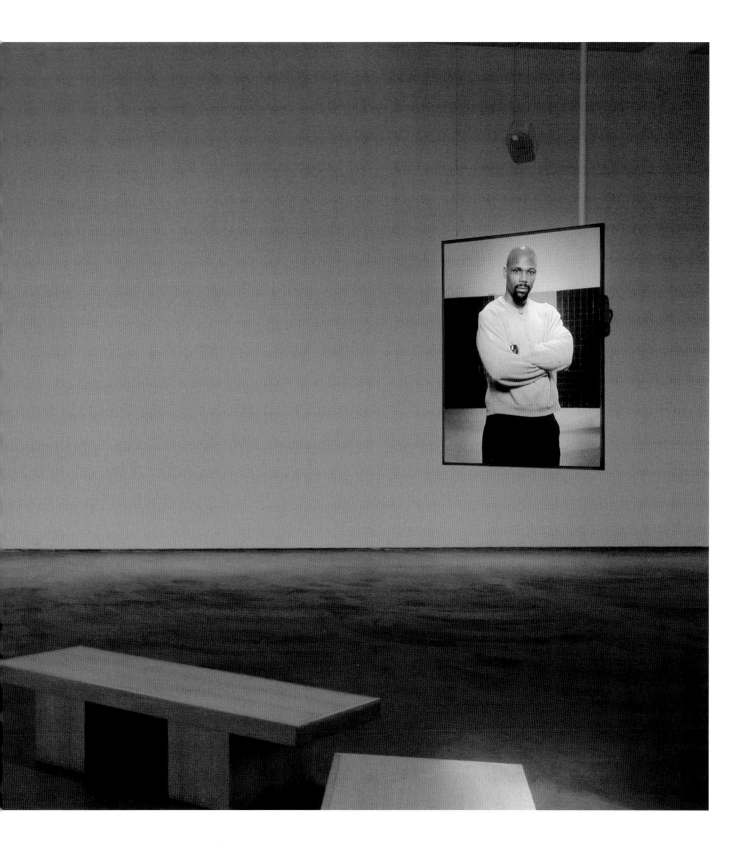

Fiona Tan
Lives and works in Amsterdam

Biography

1966
Born in Pekanbaru, Indonesia

1988 – 1992
Gerrit Rietveld Academie,
Amsterdam

1996 – 98
Rijksakademie van Beeldende Kunst,
Amsterdam

Solo Exhibitions

1995
Inside Out, Montevideo/
Time Based Art, Amsterdam

1996 – 97
Open Studio, Rijksakademie van
Beeldende Kunst, Amsterdam

1998
J.C. Van Lanschot Prijs, Stedelijk
Museum voor Aktuele Kunst,
Ghent, Belgium

Linneaus' Flower Clock, Stedelijk
Museum, Sittard, Netherlands

1999
Cradle, Galerie Paul Andriesse,
Amsterdam

Elsewhere is a Negative Mirror,
Begane Grond, Utrecht, Netherlands

Roll I & II, De Pont Foundation
for Contemporary Art, Tilburg,
Netherlands

Smoke Screen, De Balie, Amsterdam

2000
Carwreck Cinema, Aussendienst,
Hamburg, Germany (exh. cat.)

Lift, Galerie Paul Andriesse,
Amsterdam

Linnaeus' Flower Clock, Galleria
Massimo de Carlo, Milan

Scenario, Kunstverein Hamburg,
Hamburg, Germany (exh. cat.)

2001
Fiona Tan — Film and Video Works,
Wako Works of Art, Tokyo

Fiona Tan, Recent Works, Galerie
Michel Rein, Paris

Matrix 144, Wadsworth Atheneum
Museum of Art, Hartford, Conn.

Rain, Galerie Elisabeth Kaufmann,
Zürich

2002
Fiona Tan — Akte 1, Villa Arson
Centre National d'Art Contemporain,
Nice; traveled to De Pont
Foundation for Contemporary Art,
Tilburg, Netherlands, and Akademie
der Kunsten, Berlin (exh. cat.)

2003
New and Recent Works, Frith Street
Gallery, London

2004
Fiona Tan, IASPIS Gallery, Stockholm

Linnaeus' Flower Clock, Wako Works
of Art, Tokyo

Group Exhibitions

1994
Totenklage/Lacrymosa, Stedelijk
Museum Bureau, Amsterdam

1995
Beyond the Bridge, Nederlands
Filmmuseum, Amsterdam

1996
*hARTware — Dutch Media Art in the
90s,* Künstlerhaus, Dortmund,
Germany

1997
Cities on the Move, Wiener
Secession, Vienna; traveled to
Hayward Gallery, London; Louisiana
Museum, Denmark; Kiasma
Museum of Contemporary Art,
Helsinki, PS1 Contemporary Art,
New York; CAPC Musée d'Art
Contemporain de Bordeaux (exh. cat.)

Hong Kong — Perfumed Harbour, De
Appel, Amsterdam

Second Johannesburg Biennale,
Johannesburg

*The Second — Time Based Art from
the Netherlands,* Stedelijk Museum
Amsterdam; traveled to Museo Del
Chopo, Mexico City; Fine Arts
Museum, Taipei; ICC, Tokyo (exh. cat.)

1998
Biennale de l'image Paris '98,
E.N.S.B.A, Paris

Déplacements, Galerie Anton Weller,
Paris

Entrè-fiction, Centre d'Art
Contemporain Rueil-Malmaison,
Rueil-Malmaison, France

Power Up, Gemeentemuseum
Arnhem, Arnhem, Netherlands

*Rineke Dijkstra, Tracey Moffatt,
Fiona Tan,* S.M.A.K., Ghent, Belgium

Scope, Artist Space, New York

Traces of Science in Art, Het
Trippenhuis, Amsterdam (exh. cat.)

unlimited.nl, De Appel, Amsterdam

World Wide Video Festival, Stedelijk
Museum, Amsterdam

1999
Go Away, Royal College of Art,
London (exh. cat.)

*Huitième Biennale de l'Image en
Mouvement,* Centre pour l'image
contemporaine, Geneva (exh. cat.)

International Biennale of Photography,
Centro de la Imagen, Mexico City

Life Cycles, Galerie fur
Zeitgenossische Kunst, Leipzig
(exh. cat.)

Stimuli, Witte de With, Rotterdam

Zug (luft), Museum Kurhaus Klev,
Kleve, Germany

2000
Art Unlimited, Art Basel, Basel,
Switzerland

Cinema Without Walls, Musuem
Boijmans van Beuningen, Rotterdam

Etat des lieux # 2, Centre d'Art
Contemporain, Fribourg, Switzerland

Et l'art se met au monde, Institute
d'Art Contemporain, Villeurbanne,
France

Finsternis/Finsterre, Palazzo delle
Pappesse, Pisa, Italy

Hers, Video as a Female Terrain,
Landesmuseum Johanneum, Graz,
Switzerland (exh. cat.)

Kingdom of Shadows, International
Documentary Film Festival,
Amsterdam

Shanghai Spirit, Shanghai Biennale,
Shanghai Art Museum (exh. cat.)

Still/Moving, Museum of Modern Art, Kyoto (exh. cat.)

2001
Art Unlimited, Art Basel, Basel, Switzerland

Endtroducing, Villa Arson, Nice

Futureland, Städtisches Museum Abteiberg, Mönchengladbach, Germany; traveled to Museum Bommel van Dam, Venlo, Netherlands (exh. cat.)

Mobile Walls — Recent Acquisitions, Museum Boijmans Van Beuningen, Rotterdam

My Generation: 24 Hours of Video Art, Atlantis Gallery, London

Recent Acquisitions, Stedelijk Museum Amsterdam

Sculpture Contemporaine, Institut d'Art Contemporain, Lyon, France

Second Berlin Biennale, Berlin (exh. cat.)

Venice Biennale, Venice (exh. cat.)

Yokohama 2001, International Triennial of Contemporary Art, Yokohama (exh. cat.)

2002
Documenta 11, Kassel, Germany (exh. cat.)

On the Waterfront, Stedelijk Museum Schiedam, Netherlands

Selfexposure, Rijksuniversiteit Groningen, Netherlands

Tele-Journeys, MIT List Arts Center, Cambridge, Mass. (exh. cat.)

2003
About Land, Sea and Faces, Erasmus House, Jakarta Contour Audio Visual Festival, Mechelen, Belgium

Home and Away, Vancouver Art Gallery, Vancouver (exh. cat.)

ID, Nils Staerk Contemporary Art, Copenhagen

Istanbul Biennale, Istanbul (exh. cat.) *Kingdom of Shadows,* International Film Festival, Rotterdam

Link, Stedelijk Museum, Amsterdam (exh. cat.)

Rijksakademie, Victoria Miro Gallery, London

Shine, Museum Boijmans Van Beuningen, Rotterdam (exh. cat.)

Split, Bard College, Annandale-on-Hudson, New York

Strangers: The First ICP Triennial of Photography and Video, International Center of Photography, New York (exh. cat.)

Warum!, Martin Gropius Bau, Berlin (exh. cat.)

Witnesses, Le Quartier, Centre d'Art Contemporain de Quimper, Quimper, France (exh. cat.)

2004
Artes Mundi Prize, National Museum and Gallery of Wales, Cardiff (exh. cat.)

ev+a, Limerick, Ireland (exh.cat)

Synopsis III, National Museum of Contemporary Art, Athens (exh. cat)

Time Zones, Tate Modern, London (exh. cat)

Witness, Museum of Contemporary Art, Sydney (exh. cat.)

Selected Bibliography

1998
Beeren, W. A. L. *Traces of Science in Art.* Exh. cat. Amsterdam: Edita.

Bourne, Cécile. *+8+7+3+1-1-5: Taïpei, Bangkok, Moscow, Paris, Dublin, New York.* Exh. cat. Paris: Choose One.

Westen, M. "Fiona Tan." In *Power Up.* Exh. cat. Arnhem, Germany: Museum voor Moderne Kunst.

1999
From A to B (and back again): Go Away: Artists and Travel. Exh. cat. London: Royal College of Art in association with the Arts Council of England.

Bradley, Fiona, Hou Hanru and Hans Ulrich Obrist. *Cities on the move: Urban Chaos and Global Change, East Asian Art, Architecture and Film Now.* London: Hayward Gallery.

Herst, Deanna. "Fiona Tan: DeBalie Amsterdam." *Creative Camera,* no. 360 (October–November), p. 46.

Huitieme Biennale de l'Image en Mouvement. Exh. cat. Geneva: Saint-Gervais and Centre pour l'image contemporaine.

Stimuli: Too Much Noise, Too Much Movement. Exh. cat. Rotterdam: Witte de With.

2000
Berg, Mariska van den and Gabrielle Franziska Götz, eds. *Fiona Tan Scenario.* Amsterdam: Vandenberg & Wallroth.

Lütticken, Sven. "Fiona Tan — Paul Andriesse." *Artforum* 39, no. 4 (December), p. 156.

———. "Framed and Frozen: Tiong Ang, Rineke Dijkstra, Fiona Tan, and Albert Van Westing." *Flash Art* 33, no. 211 (March–April), pp. 96–98.

Rollig, Stella, ed. *Hers, Video as a Female Terrain.* Exh. cat. Vienna and New York: Springer.

Still Moving: Contemporary Photography, Film and Video. Exh. cat. Kyoto: National Museum of Modern Art.

2001
Ardenne, Paul. "Fiona Tan: Galerie Michel Rein." *Art Press,* no. 269 (June), pp. 82–83.

Bers, Miriam. "Berlin Biennale: Affect, not Effect." *Tema Celeste,* no. 86 (November–December), pp. 74–79.

Fletcher, Annie. "Fiona Tan: A Conversation Between Fiona Tan and Annie Fletcher." *Berlin Biennale 2.* Exh. cat. Berlin.

Gioni, Massimiliano. "Speaking in Tongues: Views from a Distance." *Flash Art* 34, no. 221 (November–December), pp. 74–77.

Maiburg, Barbara, ed. *Futureland.* Exh. cat. Mönchengladbach : Städtisches Museum Abteiberg.

McNally, Owen. "Filmmaker's Atheneum Show Mixes Old, New." *The Hartford Courant,* May 17. CAL section, p. 26.

Rosoff, Patricia. "If I Fell to Earth Full Grown." *The Hartford Advocate,* May 31, p.19.

Szeemann, Harald. *La Biennale di Venezia: 49. esposizione internazionale d'arte. Plateau of Humankind.* Exh. cat. Milan, Venice: Electa and La Biennale di Venezia.

2002

Carels, Edwin, de Pauw, Josse and Adrea Wiarda. A-Prior 8 — Fiona Tan. Exh. cat. Brussels: A-Prior.

Carrayrou, Stéphane. "Fiona Tan: Breathing Images." Art Press, no. 280 (June), pp. 40–44.

Grosenick, Uta and Burkhard Riemschneider, eds. Art Now. Cologne: Taschen, pp. 492–95.

Hoek, Els and Beatrice Bismark. Fiona Tan — Akte 1 — Film and Video Projects. Exh. cat. Tilburg: De Pont Foundation for Contemporary Art. (French, German and Dutch/English editions)

Tan, Fiona. Translated by Nancy Forest-Flier. "Fiona Tan: Countenance, A Film Installation." Documenta 11. Ostfildern: Hatje Cantz, pp. 512–13, 586–88.

Tele-Journeys: Carlos Amorales, Mark Bain, Yael Bartana, Michael Blum, Sebastian Diaz Morales, Nabila Irshaid, Runa Islam, Tomoko Take, Fiona Tan. Exh. cat. Cambridge, Mass.: MIT List Visual Art Center.

2003
Eighth International Istanbul Biennale. Exh. cat. Istanbul.

"Fiona Tan: Frith Street." Art Newspaper, February, What's On section, p. 14.

Gioni, Massimiliano. "Fiona Tan." Flash Art 36, no. 229 (March–April), p. 98.

Harris, Michael. "Camera Makes Fetish of Japanese Archers." Vancouver Sun, November 18, Arts and Life section, p. C2.

Heingartner, Douglas. "Fiona Tan: De Pont Foundation." Frieze, no. 75 (May), p. 99.

Herbert, Martin. "Fiona Tan: Frith Street West End." Time Out, February 19, p. 48.

Bronwasser, Sacha. Home and Away: Crossing Cultures on the Pacific Rim. Exh. cat. Vancouver: Vancouver Art Gallery, pp. 29–36.

Knut Ebeling. Warum! Bilder diesseits und jenseits des Menschen (Why! Pictures on this side and that side of humans). Exh. cat. Ostfildern: Hatje Cantz.

Link — Municipal Art Acquisitions 2002–2003: Photography. Exh. cat. Amsterdam: Stedelijk Museum.

Menin, Samuele and Valentina Sansone. "Focus Video and Film." Flash Art 36, no. 229 (March–April), p. 92–99.

Onfray, Michel. "To Enjoy and Bring Enjoyment." In Shine: Wishful Fantasies and Visions of the Future in Contemporary Art. Exh. cat. Rotterdam: Museum Boijmans Van Beuningen.

Volk, Gregory. Strangers: The First ICP Triennial of Photography and Video. Exh. cat. New York: International Center of Photography, pp. 158–161.

2004
Baume, Nicholas. Witness. Exh. cat. Sydney: Museum of Contemporary Art.

Cooke, Lynne. "Thin Cities." In Synopsis III. Exh. cat. Athens: National Museum of Contemporary Art.

Herbstreuth, Peter. "Fiona Tan: Akademie der Künste." Flash Art 37, no. 235 (March–April), p. 112.

Wahjudi, Claudia. "Fiona Tan — Akte 1: Akademie der Kunste." Kunstforum International, no. 169 (March–April), pp. 228–29.

Wallis, Brian. "Fiona Tan." In Artes Mundi. Exh. cat. Cardiff, Wales: National Museum and Gallery.

Prizes

1996
Prix de Rome, Film/Video: nominee

1997
Prize for the best national debut film, the Netherlands Film Festival

1998
J.C. Van Lanschot Prize for Sculpture, Belgium/the Netherlands: First Prize

2001–2002
DAAD scholarship and residency, Berlin

2003
IASPIS grant and residency, Stockholm

2004
ICP Infinity Award for Art, New York
Artes Mundi Prize, Cardiff, Wales: nominee

Collections

Centre Pompidou, Paris
Don Rubell Family Collection, Miami
Fondazione Sandretto Re Rebaudengo, Turin, Italy
Fonds National d'Art Contemporain, Puteaux, France
Foundation De Pont, Tilburg, Netherlands
FRAC Lorraine, France
FRAC Provence-Alpes-Côte d'Azur, France
FRAC Villeurbaine, Lyon, France
Frans Hals Museum, Haarlem
Musée d'Art Moderne de la Ville Paris
Museum Booijmans van Beuningen, Rotterdam
National Museum of Modern Art, Kyoto
Rabobank Nederland
Schaulager, Laurenz Foundation, Basel
Stedelijk Museum Amsterdam
Stedelijk Museum Het Domein, Sittard, Netherlands
Thomas Dane, London
Twenty-first Century Museum of Contemporary Art, Kanazawa, Japan

Curators' Acknowledgments

We would like to thank Elizabeth Smith, James W. Alsdorf Chief Curator at the MCA; our colleagues at the Hammer Museum, Russell Ferguson and Aimee Chang; and at the New Museum, Dan Cameron and Trevor Smith, for fostering this innovative model for collaboration and their unwavering support during the development of our first project. MCA Trustee Jack Guthman graciously offered assistance in contacting the prisons. At the MCA we would like to extend our profound thanks to Jennifer Draffen, who adroitly drafted complex contracts for this organizational arrangement, and Julie Havel, who effectively secured government and foundation support for the exhibition. We are grateful to Tessa Jackson and Joel Snyder for their insightful texts. Hal Kugeler, Kari Dahlgren, and Kythzia Jurado de Campa worked creatively and expertly with the artist and contributors to produce an elegant publication of Tan's new work. Curatorial interns Shana Forliani and Jennifer Geith provided valuable research assistance. Jennifer Harris skillfully coordinated photo rights and reproductions. Thanks to Norah Delaney for arranging Fiona Tan's lecture. We would especially like to thank Dennis O'Shea and Brad Martin for their astute attention to the technical details of this exhibition. Finally, we would like to thank Fiona Tan, with whom it was a great pleasure to collaborate on this remarkable new work.

Francesco Bonami
Manilow Senior Curator

Julie Rodrigues Widholm
Assistant Curator

Artist's Acknowledgments

Correction
Jaap van Hoewijk, producer
Jacko van 't Hof, cinematographer
Hugo Dijkstal, sound design
Joke Treffers, online editing
Ronald van Dieren, colour correction
Edit Point, dvd mastering
Ivo van Stiphout, installation assistance
Chris Fox, studio assistance

With thanks to
Brian Fairchild
Javier Cavazos
Soen Houw and Lesley Tan
Hugo, Ruben and Niels Dijkstal
Charlotte Bogaert, Tim and Bart
Frith Street Gallery, London

MCA Chicago
Elizabeth Smith
Francesco Bonami
Julie Rodrigues Widholm
Dennis O'Shea
Kari Dahlgren
Kythzia Jurado de Campa

Photography Credits